Horace King, BUILDER OF BRIDGES

OBIORA N. ANEKWE
MEd, EdD, MS Bioethics, MST

To order additional copies of this book, contact:
Xlibris
844-714-8691
www.Xlibris.com
Orders@Xlibris.com

ISBN: Softcover 978-1-6698-1966-0
 Hardcover 978-1-6698-1967-7
 EBook 978-1-6698-1965-3
Library of Congress Control Number: 2022906590

Print information available on the last page

Rev. date: 04/12/2022

Images of Author by Alexis S. Anekwe

It is not where you begin that determines your fate. Rather, it is the persistence within you that determines where you end up.

—*Obiora N. Anekwe*

Contents

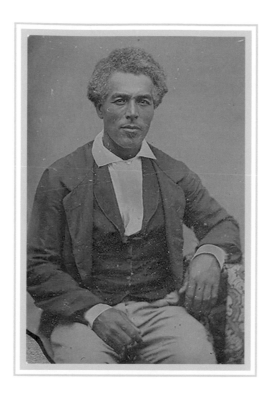

Horace King
(1807-1885)

In 1807, Horace King was born into slavery in the Chesterfield District of South Carolina. King was of mixed African, European, and Catawba ancestry. In 1830, John Godwin, a contractor in Cheraw, South Carolina, hired him as an enslaved person. King's ethnic background included African, European, and Catawba Indian ancestry.

As an enslaved person until 1846, Horace King learned quickly and became a master bridge architect, engineer, and construction manager throughout Alabama, Georgia, and northeastern Mississippi during the mid-nineteenth century. Horace King and John Godwin worked as respected partners on major construction projects, including building the Dillingham Bridge, which was the first public bridge connecting Georgia and Alabama.

After King was freed from enslavement, he became the superintendent and architect of bridges in Alabama and Mississippi. As such, his wealth grew until he eventually became the wealthiest Black man in Alabama. From 1868 to 1872, King later served as a Republican member of the Alabama House of Representatives.

After his public service as a legislator, Horace King moved to LaGrange, Georgia to continue building bridges, while expanding his company to construct business and school buildings. Before his death in 1885, King had five children-Washington W., Marshall Ney, John Thomas, Annie Elizabeth, and George-who continued the family-owned business of construction.

Horace King was married twice. In 1864, King's first wife, Frances Thomas King, died. He married his second wife, Sarah Jane Jones McManus, after the end of the American Civil War.

The Bridge

Builders Series

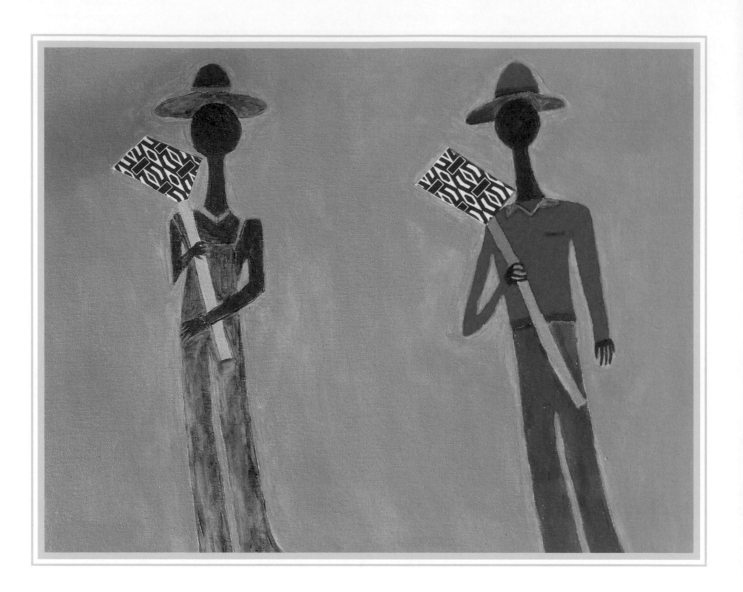

Panel No. 1

In my image, the two bridge builders stand next to each other after a demanding workday. Each bridge builder holds handheld drafting tools that were used to construct a bridge. The yellow sun, symbolized by its background, beams down on these two workers. Their sun hats protect them from the rising intensity of Southern heat. The faces of these men are void, without form, representing the many bridge builders who remain nameless. Although their names are forgotten, the bridges they have built are forever remembered.

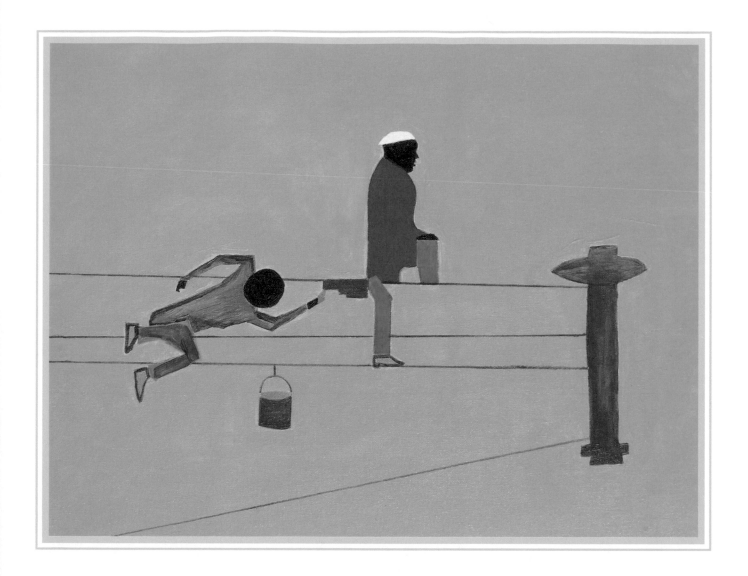

Panel No. 2

Among the heavens, two bridge builders are emerged on the fragile ropes of their constructed bridge. On the right, one builder stands reflecting on what has been constructed. Another builder, on the lower left, touches up his work with a paintbrush. Both men are at two different stages of building something incredible. Their commonality is found in a pursuit of perfection through the art of bridge making.

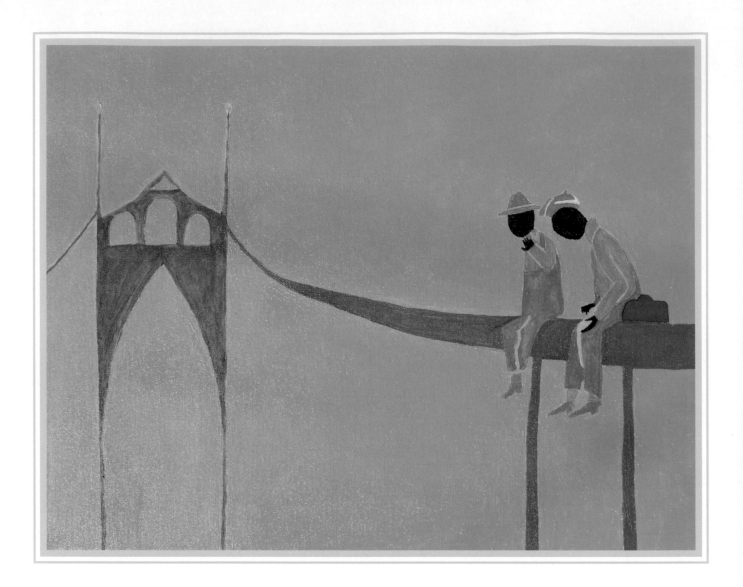

Panel No. 3

Based on a photograph of three seated bridge builders, my painting depicts a similar scene, but with only two workers. The two men wear similar attire with blue jean overalls and yellow shirts, socks, and shoes. Both men also wear hats, each distinct from the other. The bridge builder to the far right has a red lunch box pictured next to him. The brown bridge they created is more modern than those built during the time of Horace King.

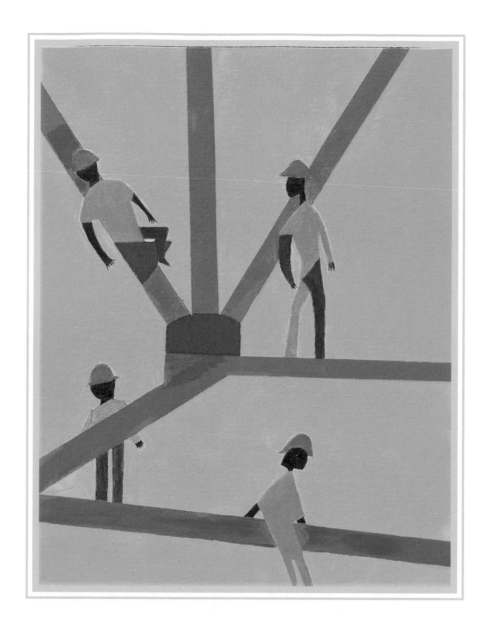

Panel No. 4

In a stylistic fashion, four bridge makers pose at a section of the bridge they are building. Their uniformed attire denotes that they work in connection to one another. Their individual tasks help attain a unified goal. Although these men work in dangerous conditions, their internal bravery enables them to persevere. Within the panel, my human figures were drawn geometrically, which highlights the significance of geometry in designing well-made bridges.

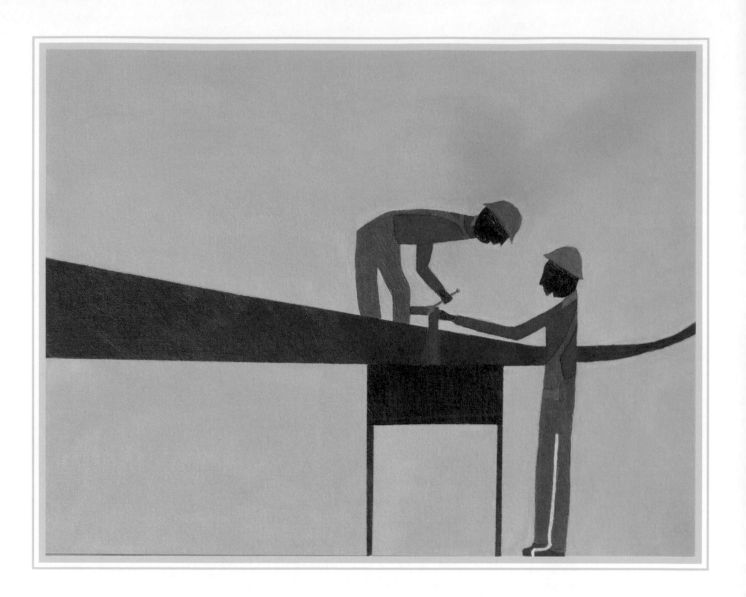

Panel No. 5

Under a blistering sun and yellow-drenched sky, two twin-like figures work to repair a section of a bridge. They are skillful and tactful in how the bridge is repaired. Careful not to make a mistake, these two men are self-aware of what they are doing. This panel demonstrates that when two or more people work together in a common cause, things get done!

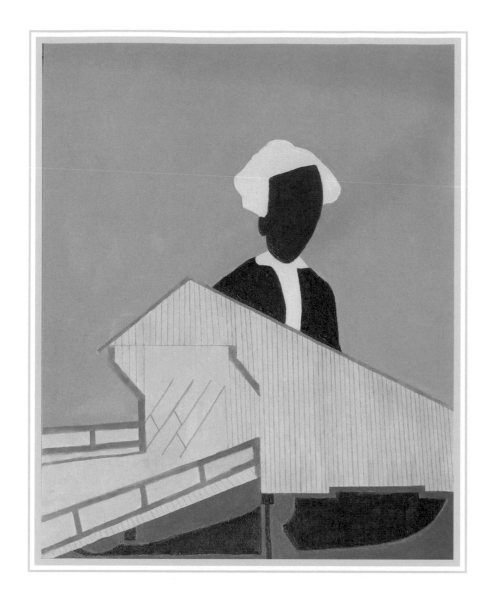

Panel No. 6

Pictured in Panel No. 6, the Glass Road Bridge is shown here as a long, wooden covered bridge. Horace King, the designer and builder of the bridge, is shown at the top of the panel. As a man born into slavery, King used new interlocking prefabricated construction methods to create this bridge and many others.

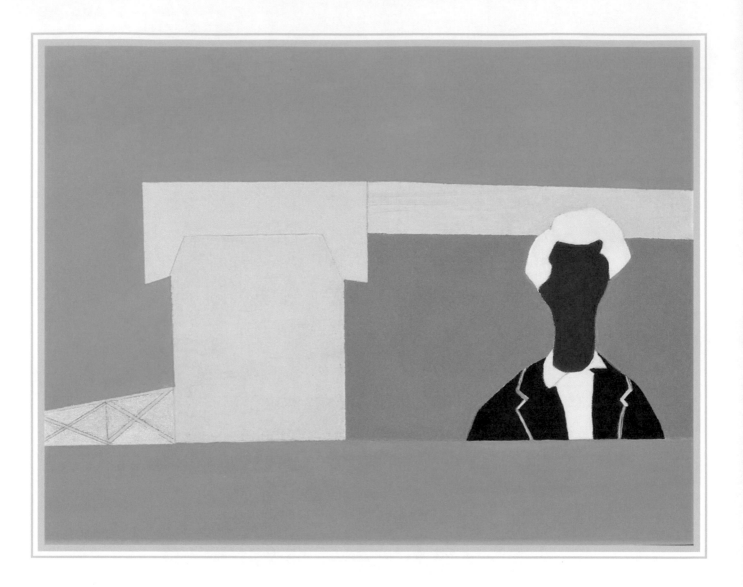

Panel No. 7

The bridge builder Horace King is shown in the foreground on the right side of the panel. His hair is white as snow, while his attire is traditional in style. Brightly colored and geometrically sound, the bridge in the background was designed and built by King in 1865. Known as the Dillingham Street Bridge of Columbus, Georgia, this bridge was the first architectural structure to connect Georgia and Alabama. Some historians believe that the Dillingham Street Bridge was erected on the same location where Governor James Oglethorpe of Georgia signed a treaty of cooperation with the Creek Indians.

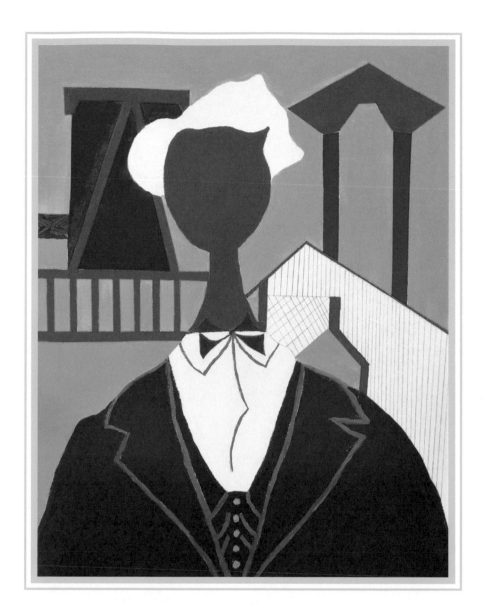

Panel No. 8

As the cover image for my book, Horace King is depicted center stage in this portrait. His upper body and neck are exaggerated and elongated. He remains faceless as images of bridges surround his body. The lower right-side bridge shows the Glass Road Bridge, for which King designed and built. The top right- and left-side bridges demonstrate examples of covered bridges Horace King designed and built. The middle-left image depicts a railroad track. King often built bridges with railroad tracks for the Confederacy during the American Civil War to transport military goods. Most, if not all, such bridges were destroyed during and after the war.

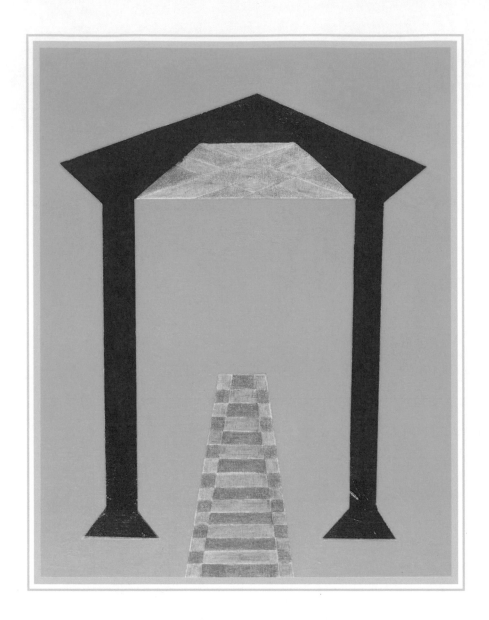

Panel No. 9

Drenched in fiery red, this one-dimensional view of a bridge is multidimensional in meaning. The bottom middle train tracks demonstrate that travel is infinite, without boundaries. The lightly penciled brown-and-red upper middle area serves as support beams for the bridge. This is symbolic of how emotional support also paradoxically builds bridges.

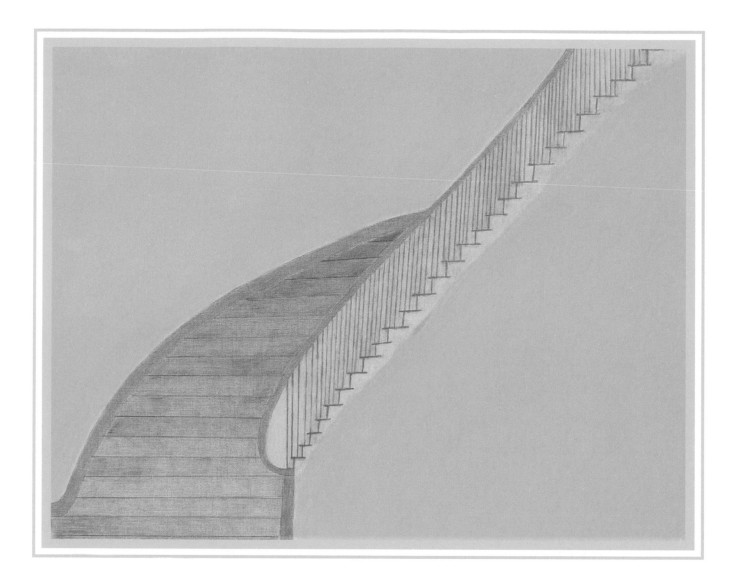

Panel No. 10

Horace King was not only an extraordinary bridge builder, but he also was a profound builder of interior steps. As shown in Panel No. 10, Horace King employed bridge building techniques to design the spiral staircase in the Alabama State Capitol. A central support was not required. Although the staircase's original color is white, I used red in my depiction to emphasize King's glorious proficiency as an architect.

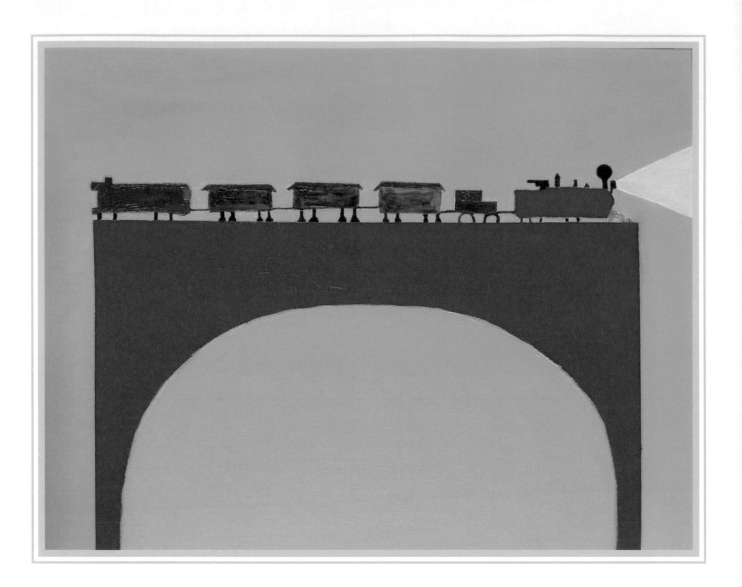

Panel No. 11

As the American Civil War approached, Horace King opposed secession of the Southern states. He was a confirmed Unionist. After the outbreak of hostilities, King continued to work as an architect and bridge builder. Panel No. 11 depicts a bridge King built at the time. The image also shows cargo being shipped throughout the Southern states during the war. Many of King's bridges were destroyed by Union troops as the American Civil War approached its end in 1864. One such bridge was Moore's Bridge, which was owned by King.

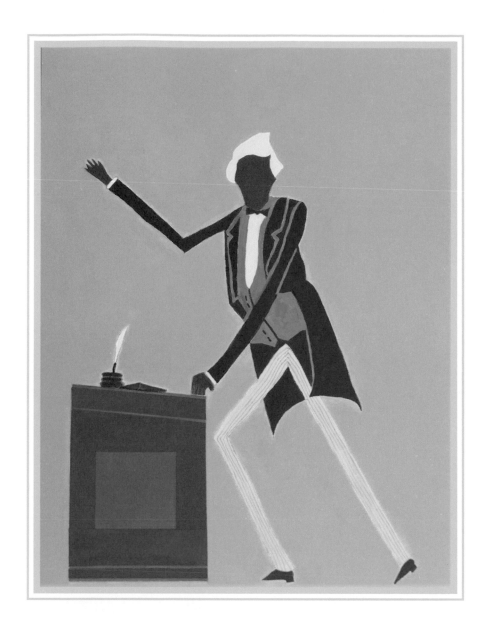

Panel No. 12

In 1868, Horace King was elected to the Alabama House of Representatives as a Republican representing Russell County. He did not take his seat for more than a year in November of 1869. To say the least, King was a reluctant legislator who voted 78 percent of the time. In 1870, King was reelected. He did not seek reelection in 1872. The panel image depicts Horace King speaking during a legislative meeting. King's right hand is lifted as his body symbiotically leans toward the podium.

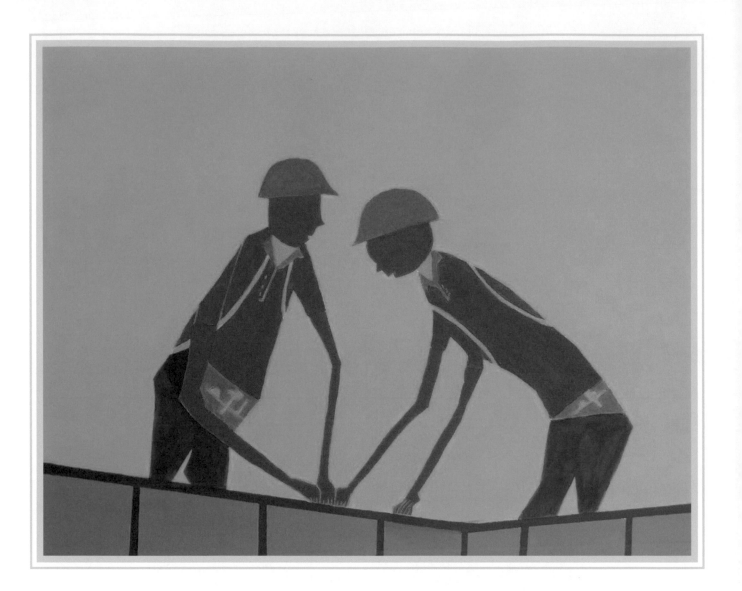

Panel No. 13

In Panel No. 13, two bridge builders work together simultaneously to construct a bridge. They are depicted putting the finishing touches on their work. These men are modern-day workers who understand the contemporary skills of brick masonry. Their work attire is brightly rendered in orange, red, gold, and blue. Inspired by the stylistic renderings of the late artist Benny Andrews, the elongated hand(s) and body formations represent the exaggerated context of their creative task.

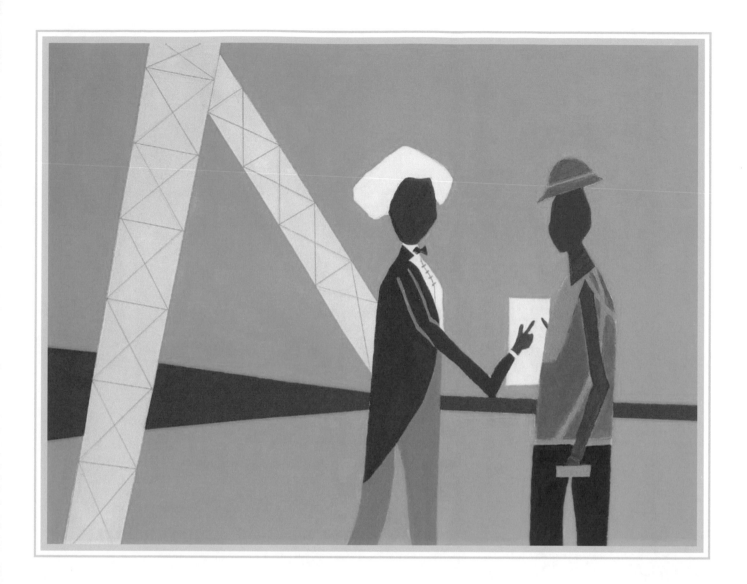

Panel No. 14

Standing in front of an incomplete yellow-and-red bridge, Horace King and an unidentified worker discuss the plans for completion. King is dressed in the attire of his day, while the worker is dressed in modern construction attire. I decided to integrate the two stylistic dress attires in this panel to symbolize how consummate bridge making transcends both time and space.

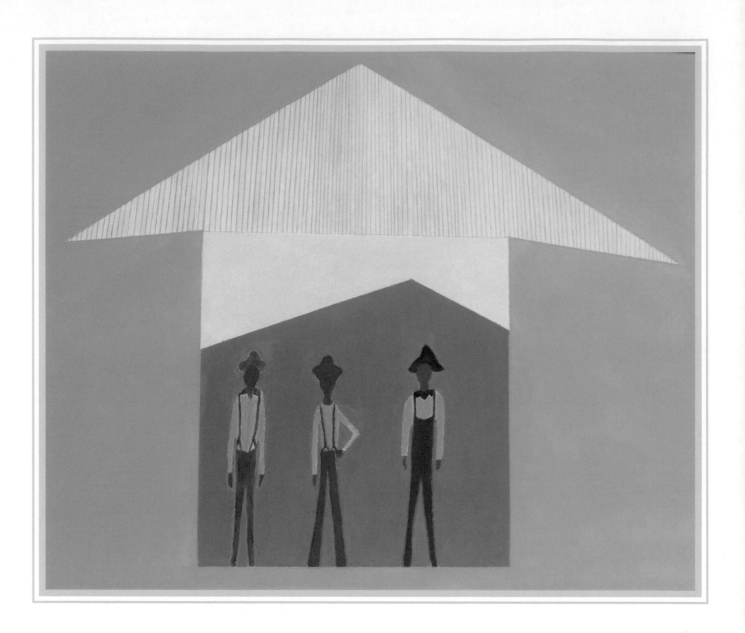

Panel No. 15

In Panel No. 15, three men are shown in their work attire. John T. King, the son of Horace King, is pictured in the middle with two unidentified workers in front of his lumberyard. Along with his four siblings, John T. King continued the tradition of his father by establishing a successful construction company known as the King Brothers Bridge Company. Their company built not only bridges but also schools, public service enterprises, and businesses.

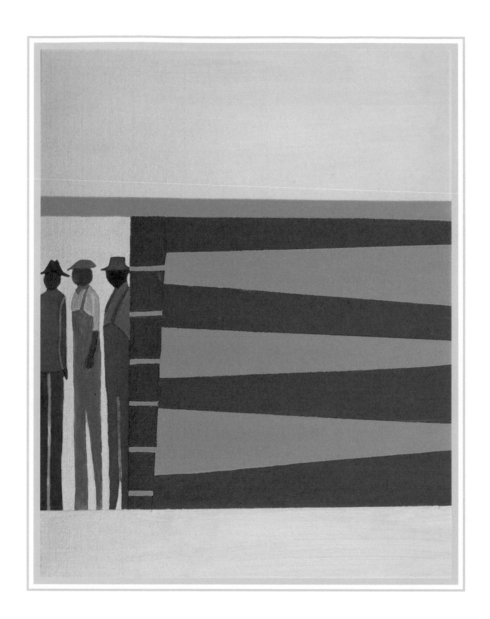

Panel No. 16

Taken from a photograph, the panel shows the wooden foundations from a structure in Eufaula, Alabama. This area was sunk by Horace King's company crew in 1838. The three workers in this image are shown after excavating the foundation for a new pier.

Panel No. 17

Panel No. 17 is based on a photograph of Horace King and his sons. In my depiction, I exclude Horace King and focus primarily on his sons. The original photograph was created around 1870. Pictured in the montage are Horace King's sons: Marshall N. King (top right), Washington W. King (top left), John T. King (bottom right), and George H. King (bottom left). These brothers formed a King construction company that worked throughout the southeast of North America.

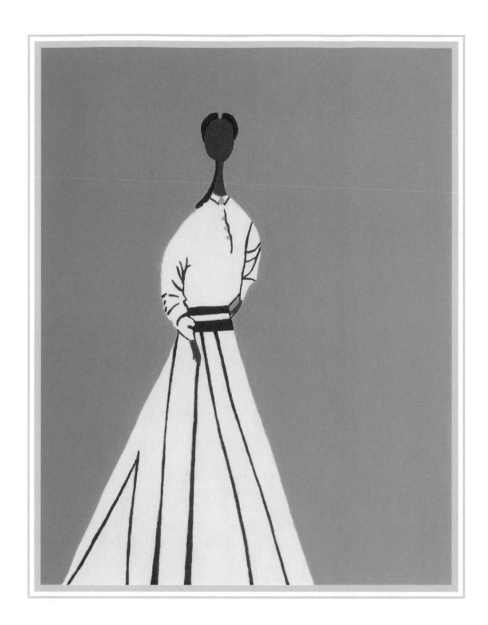

Panel No. 18

With an elongated neck and oval face, Annie Elizabeth King is shown in 1870 as the only daughter of Horace and Frances King. Annie was once married briefly, then she later divorced. After her divorce, she moved to LaGrange, Georgia, to work with her brothers and participate as a full partner in the King Brothers Bridge Company.

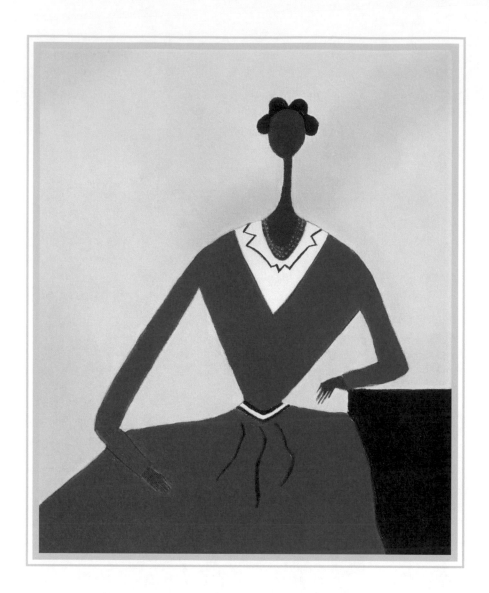

Panel No. 19

Panel No. 19 depicts the elongated body features of Frances Gould Thomas King, the first wife of Horace King. My image is based on a photograph of Frances taken in 1855. Horace and Frances were married in April 1839. They both shared similar triracial backgrounds.

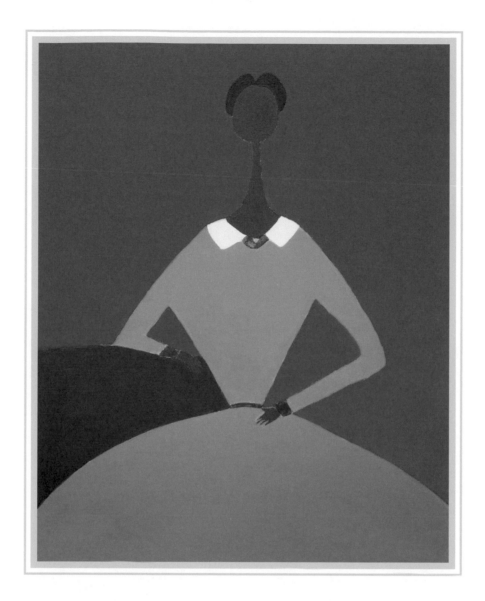

Panel No. 20

In this image, Sarah Jane Jones King is portrayed. Sarah became Horace King's second wife after the death of his first wife, Frances. She shared his triracial background much like his first wife. Here, Sarah is seated wearing a bright mustard-yellow dress. The vivid colors in my painting emphasize the beauty of King's wife, Sarah. My rendered image of Sarah is based on a photograph taken in 1865.

Captions
And
Panel Details

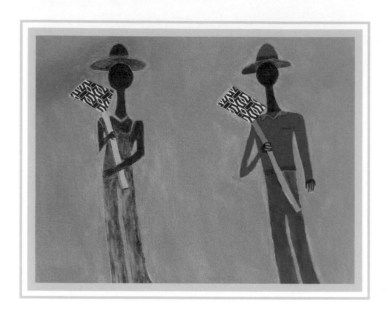

Panel #1
c. 2020
14 by 18 inches
Acrylic Paint and Collage Materials
Brooklyn, New York

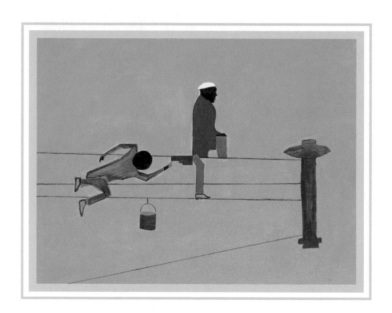

Panel #2
c. 2020
14 by 18 inches
Acrylic Paint
Brooklyn, New York

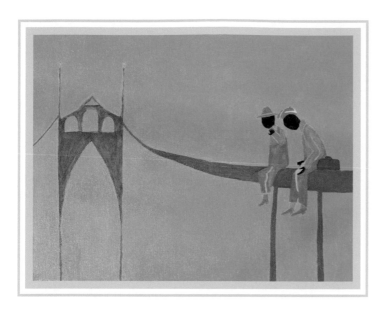

Panel #3
c. 2020
14 by 18 inches
Acrylic Paint
Brooklyn, New York

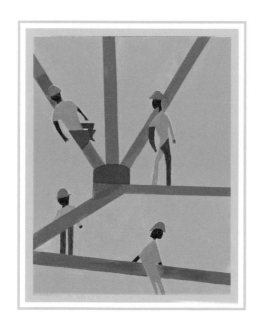

Panel #4
c. 2020
14 by 18 inches
Acrylic Paint
Brooklyn, New York

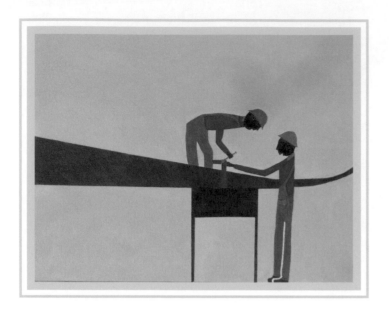

Panel #5
c. 2020
14 by 18 inches
Acrylic Paint
Brooklyn, New York

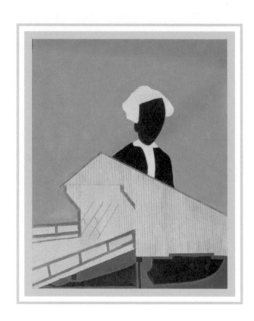

Panel #6
c. 2020
14 by 18 inches
Acrylic Paint, Colored Markers, and Pencil
Brooklyn, New York

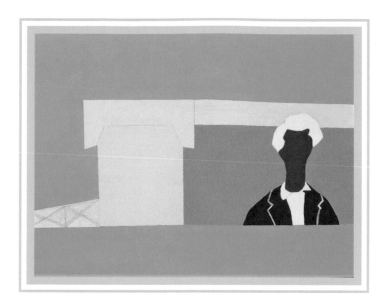

Panel #7
c. 2020
14 by 18 inches
Acrylic Paint and Colored Pencils
Brooklyn, New York

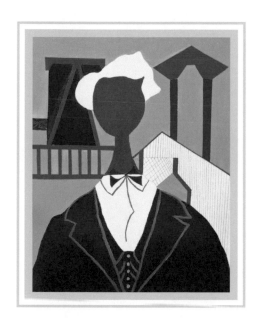

Panel #8
c. 2021
14 by 18 inches
Acrylic and Gouache Paint
Schroon Lake, New York

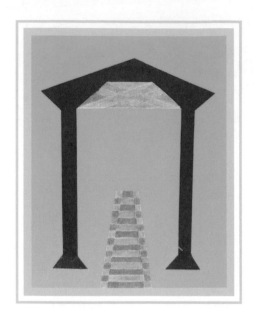

Panel #9
c. 2020
14 by 18 inches
Acrylic Paint and Colored Pencils
Schroon Lake, New York

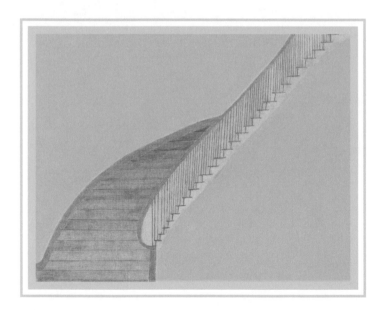

Panel #10
c. 2020
14 by 18 inches
Acrylic Paint and Colored Pencils
Schroon Lake, New York

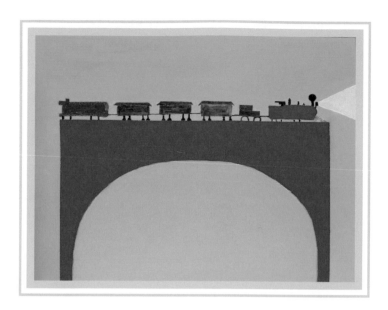

Panel #11
c. 2020
14 by 18 inches
Acrylic Paint
Schroon Lake, New York

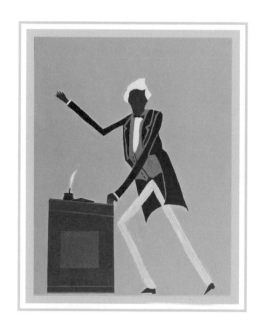

Panel #12
c. 2020
14 by 18 inches
Acrylic Paint and Colored Markers
Brooklyn, New York

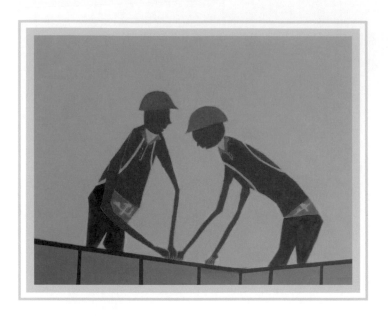

Panel #13
c. 2020
14 by 18 inches
Acrylic Paint
Brooklyn, New York

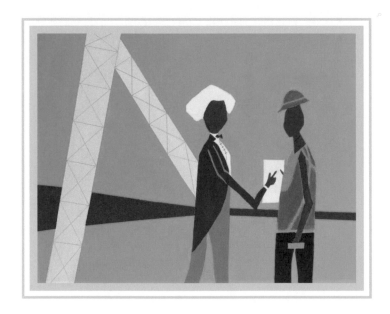

Panel #14
c. 2020
14 by 18 inches
Acrylic Paint and Pencil
Brooklyn, New York

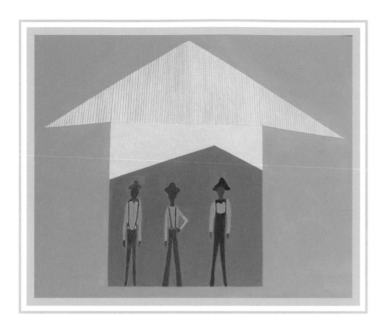

Panel #15
c. 2020
14 by 18 inches
Acrylic Paint, Colored Marker, and Pencil
Brooklyn, New York

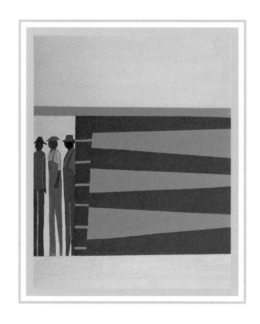

Panel #16
c. 2020
14 by 18 inches
Acrylic Paint
Brooklyn, New York

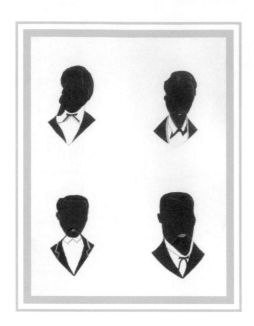

Panel #17
c. 2020
14 by 18 inches
Acrylic Paint
Brooklyn, New York

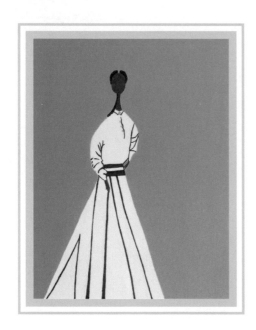

Panel #18
c. 2021
14 by 18 inches
Acrylic Paint
Brooklyn, New York

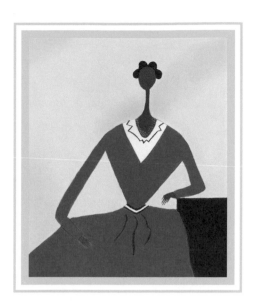

Panel #19
c. 2021
14 by 18 inches
Acrylic Paint
Brooklyn, New York

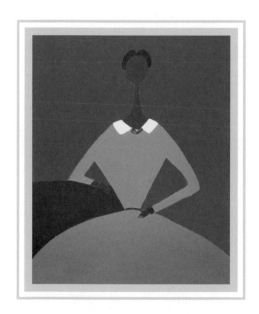

Panel #20
c. 2021
14 by 18 inches
Acrylic and Gouache Paint
Schroon Lake, New York

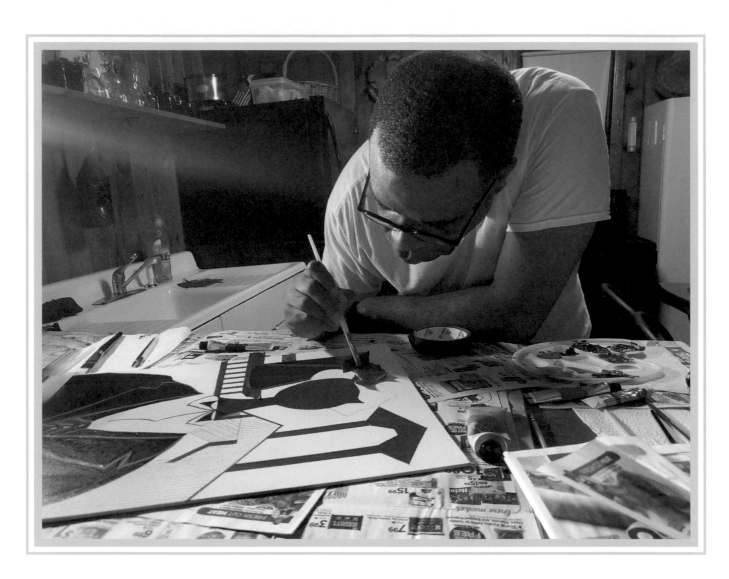

Image of Obiora painting his book's cover image in Schroon Lake, New York.

Become A Bridge Builder
By Obiora N. Anekwe

Find your greatest strength
Among the seamless skies.
Work in concert
Doing the unforeseen task.

With skill and vigor
Determine your fate.

Expand your horizons
And strive to achieve.
Pave a way
For legacies to build.

Lead the way
To a new road of possibilities.
See beyond what is visible
And reach for what seems unachievable.

In the mist of it all
You will see.
Triumph will come
With hope and victory.
Then, you will become
The bridge builder you were meant to be.

Discussion Questions and Activities

A bridge builder leads a group of people toward a common goal or purpose. Bridge builders enhance, sustain, and even support societies. Horace King was a bridge builder both literally and figuratively. He worked to bring people together to achieve a common goal.

1. What can you do in your community to build bridges across all spectrums in society, regardless of gender, class, race, or religious affiliation?

2. Whom do you consider a bridge builder in your community?

3. What can you do to help other bridge builders in your community?

4. What resources or skills will you need to become a dynamic bridge builder?

5. How can you acquire these resources and skills?

6. Write your own poem that focuses on how you can build bridges among other people in your community.

7. Develop an action plan that will enhance your community. Once your plan is developed, work with other bridge builders to see how it can be implemented.

Printed in the United States
by Baker & Taylor Publisher Services